Lovers in Art

Edited By Lacey Belinda Smith

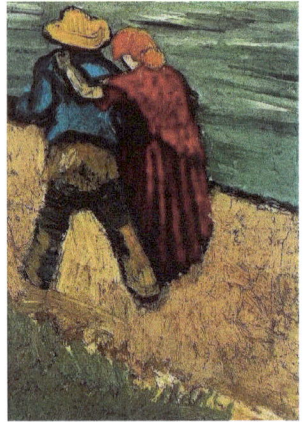

Two Lovers, Arles (Fragment)--Vincent van Gogh—1888--Post-Impressionism

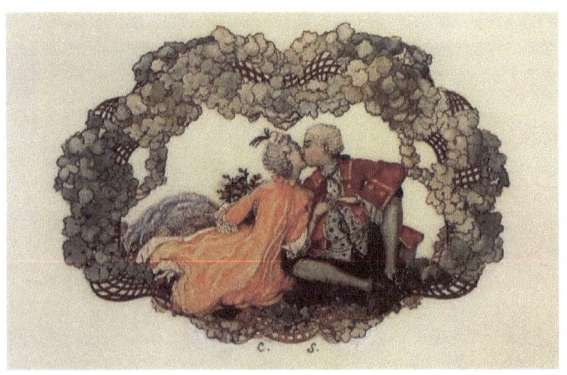

The Kiss(Поцелуй) --Konstantin Somov—1904-- Symbolism

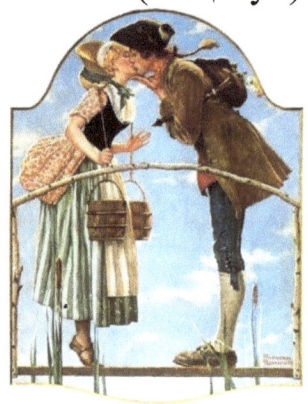

Kiss--Norman Rockwell--Regionalism

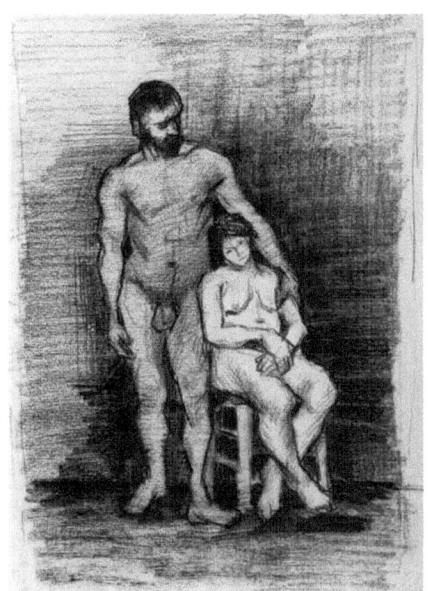

Standing Male And Seated Female Nudes--Vincent van Gogh—1887--Post-Impressionism

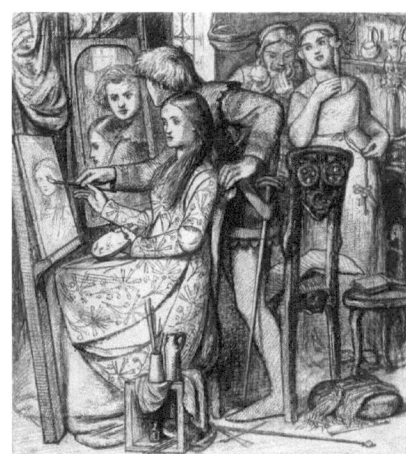

A Parable Of Love--Dante Gabriel Rossetti--1849-1850--Romanticism

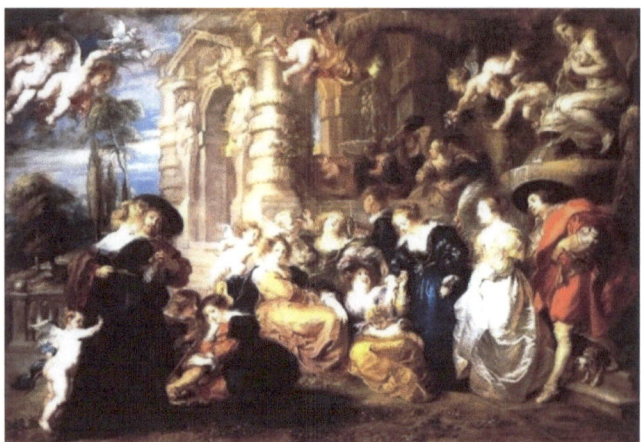

Garden Of Love--Peter Paul Rubens—1633-- Baroque

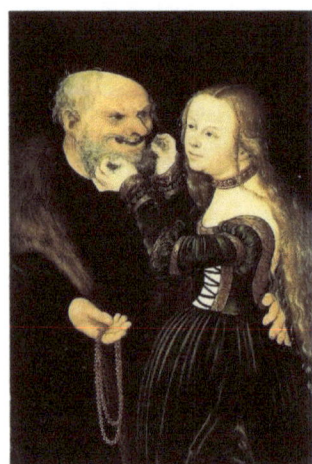

The Old Man In Love--Lucas Cranach the Elder—1525-- Northern Renaissance

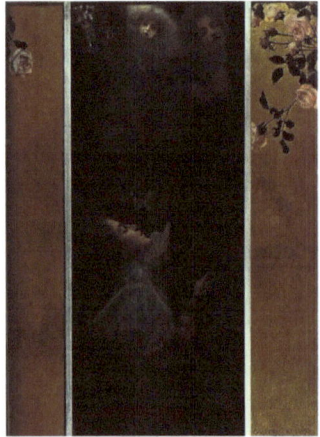

Love--Gustav Klimt—1895--Symbolism

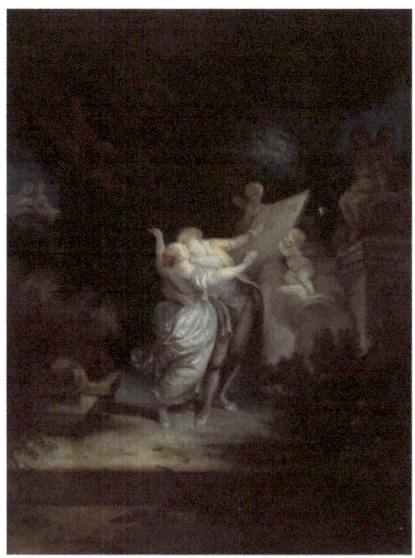

The Sermon Of Love--Jean-Honore Fragonard-- Rococo

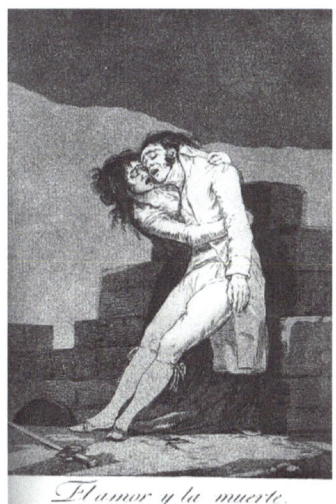

Love And Death (El amor y la muerte)--Francisco Goya—1799-- Romanticism

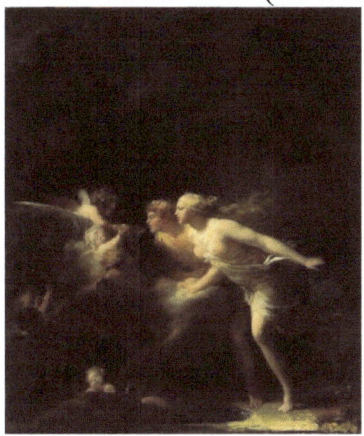

The Fountain Of Love--Jean-Honore Fragonard—1785-- Rococo

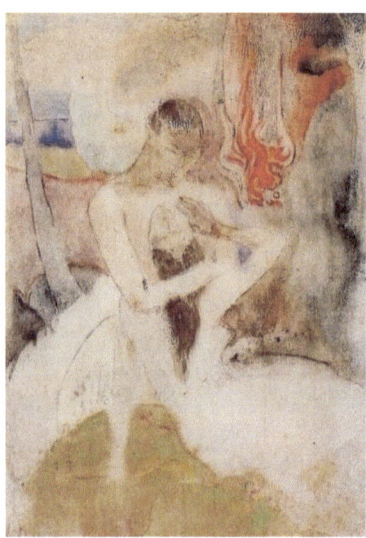

Here We Make Love--Paul Gauguin--Te faruru—1893--Post-Impressionism

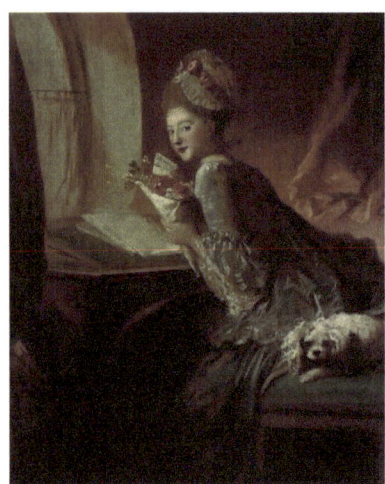

The Love Letter--Jean-Honore Fragonard--1770-1780--Rococo

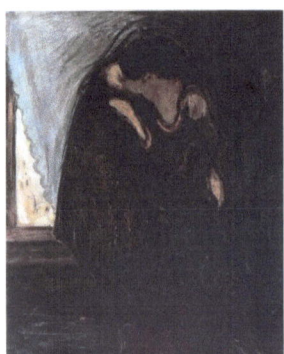

Kiss--Edvard Munch (Kyss)—1897--Expressionism

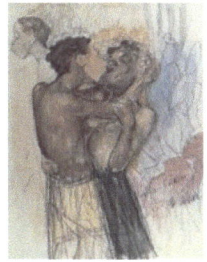

Kiss--Kuzma Petrov-Vodkin-- Symbolism

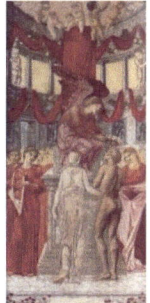

The Temple Of Love--Edward Burne-Jones-- Romanticism

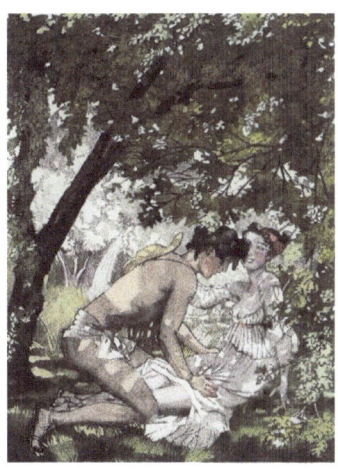

Illustration To The Novel Daphnis And Chloe 2 (Иллюстрация к роману Лонга Дафнис и Хлоя 2)--Konstantin Somov--—1930-- Art Nouveau (Modern)

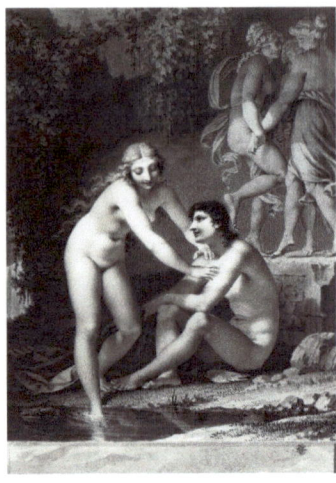

Daphnis And Chloe--Pierre-Paul Prud'hon—1802-- Neoclassicism

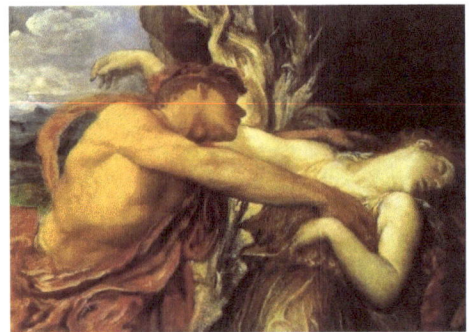

Orpheus And Eurydice--George Frederick Watts-- Symbolism

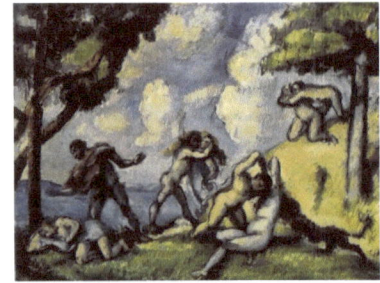

The Battle Of Love--Paul Cezanne—1880-- Post-Impressionism

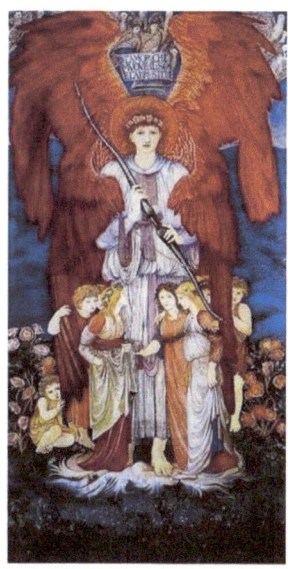

Love--Edward Burne-Jones—1880-- Romanticism

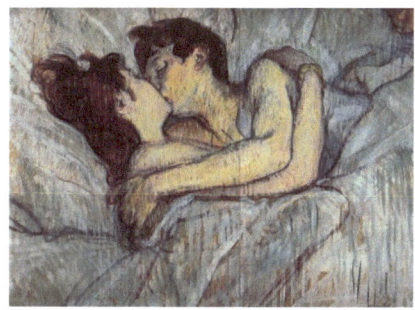

In Bed The Kiss--Henri de Toulouse-Lautrec—1892--Post-Impressionism

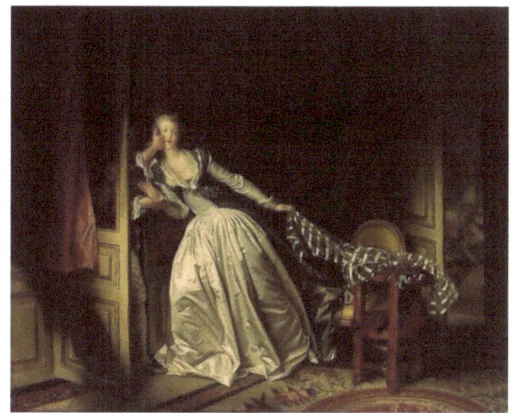

The Stolen Kiss--Jean-Honore Fragonard—1788--Rococo

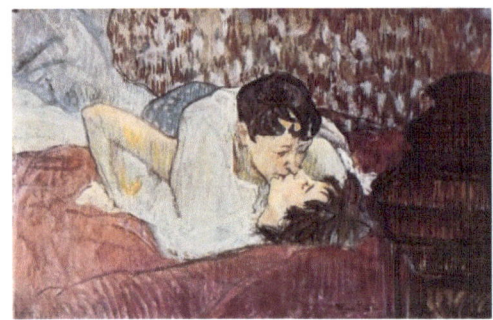

The Kiss--Henri de Toulouse-Lautrec--1892-1893--Post-Impressionism

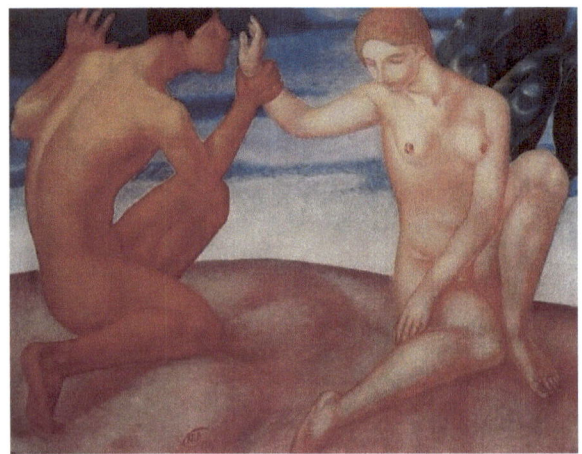

Youth (Kiss)-- Юность (Поцелуй)— --Kuzma Petrov-Vodkin--

1913-- Symbolism

By Sappho:

He's equal with the gods, that man

Peer of the gods he seems,
Who in thy presence
Sits and hears close to him
Thy silver speech-tones
And lovely laughter. 5

Ah, but the heart flutters
Under my bosom,
When I behold thee
Even a moment;
Utterance leaves me; 10

My tongue is useless;
A subtle fire
Runs through my body;
My eyes are sightless,
And my ears ringing; 15

I flush with fever,
And a strong trembling
Lays hold upon me;
Paler than grass am I,
Half dead for madness. 20

Yet must I, greatly
Daring, adore thee,
As the adventurous
Sailor makes seaward
For the lost sky-line 25

And undiscovered
Fabulous islands,
Drawn by the lure of
Beauty and summer
And the sea's secret. 30

Bridal Song

Bride, that goest to the bridal chamber
In the dove-drawn car of Aphrodite,
By a band of dimpled
Loves surrounded;

Bride, of maidens all the fairest image
Mitylene treasures of the Goddess,
Rosy-ankled Graces
Are thy playmates;

Bride, O fair and lovely, thy companions
Are the gracious hours that onward passing
For thy gladsome footsteps
Scatter garlands.

Bride, that blushing like the sweetest apple
On the very branch's end, so strangely
Overlooked, ungathered
By the gleaners;

Bride, that like the apple that was never
Overlooked but out of reach so plainly,
Only one thy rarest
Fruit may gather;

Bride, that into womanhood has ripened
For the harvest of the bridegroom only,
He alone shall taste thy
Hoarded sweetness.

He is dying, Cytherea, your tender Adonis

He is dying, Cytherea, your tender Adonis,
What should we do?
Beat your breasts, girls, tear your tunics…

Some say horsemen, some say warriors

Some say horsemen, some say warriors,
Some say a fleet of ships is the loveliest
Vision in this dark world, but I say it's
What you love.

It's easy to make this clear to everyone,
Since Helen, she who outshone
All others in beauty, left
A fine husband,

And headed for Troy
Without a thought for
Her daughter, her dear parents…
Led astray….

And I recall Anaktoria, whose sweet step
Or that flicker of light on her face,
I'd rather see than Lydian chariots
Or the armed ranks of the hoplites.

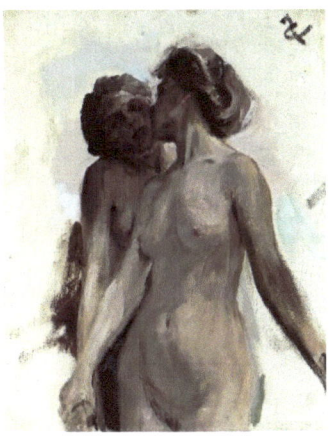

By Queen Elizabeth I:

On Monsieur's Departure
I grieve and dare not show my discontent,
I love and yet am forced to seem to hate,
I do, yet dare not say I ever meant,
I seem stark mute but inwardly do prate.
I am and not, I freeze and yet am burned,
Since from myself another self I turned.

My care is like my shadow in the sun,
Follows me flying, flies when I pursue it,
Stands and lies by me, doth what I have done.
His too familiar care doth make me rue it.
No means I find to rid him from my breast,
Till by the end of things it be supprest.

Some gentler passion slide into my mind,
For I am soft and made of melting snow;
Or be more cruel, love, and so be kind.
Let me or float or sink, be high or low.
Or let me live with some more sweet content,
Or die and so forget what love ere meant.

By Richard Le Gallienne:

A LOVE-LETTER

Darling little woman, just a little line,
 Just a little silver word
For that dear gold of thine,
 Only a whisper you have so often heard:

Only such a whisper as hidden in a shell
 Holds a little breath of all the mighty sea,
But think what a little of all its depth and swell,
 And think what a little is this little note of me.

'Darling, I love thee, that is all I live for'—
 There is the whisper stealing from the shell,
But here is the ocean, O so deep and boundless,
 And each little wave with its whisper as well.

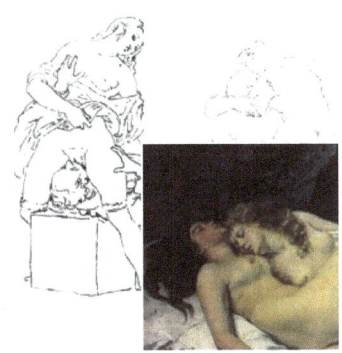

By Émile Verhaeren:

The Shining Hours

I

O the splendour of our joy, woven of gold in the silken air!

Here is our pleasant house and its airy gables, and the garden and the orchard.

Here is the bench beneath the apple-trees, whence the white spring is shed in slow, caressing petals.

Here flights of luminous wood-pigeons, like harbingers, soar in the clear sky of the countryside.

Here, kisses fallen upon earth from the mouth of the frail azure, are two blue ponds, simple and pure, artlessly bordered with involuntary flowers.

O the splendour of our joy and of ourselves in this garden where we live upon our emblems.

II

Although we saw this bright garden, wherein we pass silently, flower before our eyes, it is rather in us that grows the pleasantest and fairest garden in the world.

For we live all the flowers, all the plants and all the grasses in our laughter and our tears of pure and calm happiness.

For we live all the transparencies of the blue pond that reflects the rich growths of the golden roses and the great vermilion lilies, sun-lips and mouths.

For we live all joy, thrown out in the cries of festival and spring of our avowals, wherein heartfelt and uplifting words sing side by side.

Oh! is it not indeed in us that grows the pleasantest and the gladdest garden in the world?

III

This barbaric capital, whereon monsters writhe, soldered together by the might of claw and tooth, in a mad whirl of blood, of fiery cries, of wounds, and of jaws that bite and bite again,

This was myself before you were mine, you who are new and old, and who, from the depths of your eternity, came to me with passion and kindness in your hands.

I feel the same deep, deep things sleeping in you as in me, and our thirst for remembrance drink up the echo in which our pasts answer each to each.

Our eyes must have wept at the same hours, without our knowing, during childhood, have had the same terrors, the same happinesses, the same flashes of trust;

For I am bound to you by the unknown that watched me of old down the avenues through which my adventurous life passed; and, indeed, if I had looked more closely, I might have seen, long ago, within its eyes your own eyes open.

IV

The sky has unfolded into night, and the moon seems to watch over the sleeping silence.

All is so pure and clear; all is so pure and so pale in the air and on the lakes of the friendly countryside, that there is anguish in the fall from a reed of a drop of water, that tinkles and then is silent in the water.

But I have your hands between mine and your steadfast eyes that hold me so gently with their earnestness; and I feel that you are so much at peace with everything that nothing, not even a fleeting suspicion of fear, will overcast, be it but for a moment, the holy trust that sleeps in us as an infant rests.

V

Each hour I brood upon your goodness, so simple in its depth, I lose myself in prayers to you.

I came so late towards the gentleness of your eyes, and from so far towards your two hands stretched out quietly over the wide spaces.

I had in me so much stubborn rust that gnawed my confidence with its ravenous teeth.

I was so heavy, was so tired, I was so old with misgiving.

I was so heavy, I was so tired of the vain road of all my footsteps.

I deserved so little the wondrous joy of seeing your feet illuminate my path that I am still trembling and almost in tears, and humble, for ever and ever, before my happiness.

VI

Sometimes you wear the kindly grace of the garden in early morning that, quiet and winding, unfolds in the blue distances its pleasant paths, curved like the necks of swans.

And, at other times, you are for me the bright thrill of the swift, exalting wind that passes with its lightning fingers through the watery mane of the white pond.

At the good touch of your two hands, I feel as though leaves were caressing me lightly; and, when midday burns the garden, the shadows at once gather up the dear words with which your being trembled.

Thus, thanks to you, each moment seems to pass in me divinely; so, at the hour of wan night, when you hide within yourself, shutting your eyes, you feel my gentle, devout gaze, humbler and longer than a prayer, thank yours beneath your closed eyelids.

VII

Oh! let the passing hand knock with its futile fingers on the door; our hour is so unique, and the rest—what matters the rest with its futile fingers?

Let dismal, tiresome joy keep to the road and pass on with its rattles in its hand.

Let laughter swell and clatter and die away; let the crowd pass with its thousands of voices.

The moment is so lovely with light in the garden about us; the moment is so rare with virgin light in our heart deep down in us.

Everything tells us to expect nothing more from that which comes or passes, with tired songs and weary arms, on the roads,

And to remain the meek who bless the day, even when night is before us barricaded with darkness, loving in ourselves above all else the idea that, gently, we conceive of our love.

VIII

As in the simple ages, I have given you my heart, like a wide-spreading flower that opens pure and lovely in the dewy hours; within its moist petals my lips have rested.

The flower, I gathered it with fingers of flame; say nothing to it: for all words are perilous; it is through the eyes that soul listens to soul.

The flower that is my heart and my avowal confides in all simplicity to your lips that it is loyal, bright and good, and that we trust in virgin love as a child trusts in God.

Leave wit to flower on the hills in freakish paths of vanity; and let us give a simple welcome to the sincerity that holds our two true hearts within its crystalline hands;

Nothing is so lovely as a confession of souls one to the other, in the evening, when the flame of the uncountable diamonds burns like so many silent eyes the silence of the firmaments.

IX

Young and kindly spring who clothes our garden with beauty makes lucid our voices and words, and steeps them in his limpidity.

The breeze and the lips of the leaves babble, and slowly shed in us the syllables of their brightness.

But the best in us turns away and flees material words; a mute and mild and simple rapture, better than all speech, moors our happiness to its true heaven:

The rapture of your soul, kneeling in all simplicity before mine, and of my soul, kneeling in gentleness before yours.

X

Come with slow steps and sit near the gardenbed, whose flowers of tranquil light are shut by evening; let the great night filter through you: we are too happy for our prayer to be disturbed by its sea of dread.

Above, the pure crystal of the stars is lit up; behold the firmament clearer and more translucent than a blue pond or the stained-glass window in an apse; and then behold heaven that gazes through.

The thousand voices of the vast mystery speak around you; the thousand laws of all nature are in movement about you; the silver bows of the invisible take your soul and its fervour for target,

But you are not afraid, oh! simple heart, you are not afraid, since your faith is that the whole earth works in harmony with that love that brought forth in you life and its mystery.

Clasp then your hands tranquilly, and adore gently; a great counsel of purity floats like a strange dawn beneath the midnights of the firmament.

XI

How readily delight is aroused in her, with her eyes of fiery ecstasy, she who is gentle and resigned before life in so simple a fashion.

This evening, how a look surprised her fervour and a word transported her to the pure garden of gladness, where she was at once both queen and servant.

Humble of herself, but aglow with our two selves, she vied with me in kneeling to gather the wondrous happiness that overflowed mutually from our hearts.

We listened to the dying down in us of the violence of the exalting love imprisoned in our arms, and to the living silence that said words we did not know.

XII

At the time when I had long suffered and the hours were snares to me, you appeared to me as the welcoming light that shines from the windows on to the snow in the depths of winter evenings.

The brightness of your hospitable soul touched my heart lightly without wounding it, like a hand of tranquil warmth.

Then came a holy trust, and an open heart, and affection, and the union at last of our two loving hands, one evening of clear understanding and of gentle calm.

Since then, although summer has followed frost both in ourselves and beneath the sky whose eternal flames deck with gold all the paths of our thoughts;

And although our love has become an immense flower, springing from proud desire, that ever begins anew within our heart, to grow yet better;

I still look back on the small light that was sweet to me, the first.

XIII

And what matters the wherefores and the reasons, and who we were and who we are; all doubt is dead in this garden of blossoms that opens up in us and about us, so far from men.

I do not argue, and do not desire to know, and nothing will disturb what is but mystery and gentle raptures and involuntary fervour and tranquil soaring towards our heaven of hope.

I feel your brightness before understanding that you are so; and it is my gladness, infinitely, to perceive myself thus gently loving without asking why your voice calls me.

Let us be simple and good—and day be minister of light and affection to us; and let them say that life is not made for a love like ours.

XIV

In my dreams, I sometimes pair you with those queens who slowly descend the golden, flowered stairways of legend; I give you names that are married with beauty, splendour and gladness, and that rustle in silken syllables along verses built as a platform for the dance of words and their stately pageantries.

But how quickly I tire of the game, seeing you gentle and wise, and so little like those whose attitudes men embellish.

Your brow, so shining and pure and white with certitude, your gentle, childlike hands peaceful upon your knees, your breasts rising and falling with the rhythm of your pulse that beats like your immense, ingenuous heart,

Oh! how everything, except that and your prayer, oh! how everything is poor and empty, except the light that gazes at me and welcomes me in your naked eyes.

XV

I dedicate to your tears, to your smile, my gentlest thoughts, those I tell you, those also that remain undefined and too deep to tell.

I dedicate to your tears, to your smile, to your whole soul, my soul, with its tears and its smiles and its kiss.

See, the dawn whitens the ground that is the colour of lees of wine; shadowy bonds seem to slip and glide away with melancholy; the water of the ponds grows bright and sifts its noise; the grass glitters and the flowers open, and the golden woods free themselves from the night.

Oh! what if we could one day enter thus into the full light; oh, what if we could one day, with conquering cries and lofty prayers, with no more veils upon us and no more remorse in us, oh! what if we could one day enter together into lucid love.

XVI

I drown my entire soul in your two eyes, and the mad rapture of that frenzied soul, so that, having been steeped in their gentleness and prayer, it may be returned to me brighter and of truer temper.

O for a union that refines the being, as two golden windows in the same apse cross their differently lucent fires and interpenetrate!

I am sometimes so heavy, so weary of being one who cannot be perfect, as he would! My heart struggles with its desires, my heart whose evil weeds, between the rocks of stubbornness, rear slyly their inky or burning flowers;

My heart, so false, so true, as the day may be, my contradictory heart, my heart ever exaggerated with immense joy or with criminal fear.

XVII

To love with our eyes, let us lave our gaze of the gaze of those whose glances we have crossed, by thousands, in life that is evil and enthralled.

The dawn is of flowers and dew and the mildest sifted light; soft plumes of silver and sun seem through the mists to brush and caress the mosses in the garden.

Our blue and marvellous ponds quiver and come to life with shimmering gold; emerald wings pass under the trees; and the brightness sweeps from the roads, the garths and the hedges the damp ashen fog in which the twilight still lingers.

XVIII

In the garden of our love, summer still goes on: yonder, a golden peacock crosses an avenue; petals—pearls, emeralds, turquoises —deck the uniform slumber of the green swards.

Our blue ponds shimmer, covered with the white kiss of the snowy water-lilies; in the quincunxes, our currant bushes follow one another in procession; an iridescent insect teases the heart of a flower; the marvellous undergrowths are veined with gleams; and, like light bubbles, a thousand bees quiver along the arbours over the silver grapes.

The air is so lovely that it seems rainbow-hued; beneath the deep and radiant noons, it stirs as if it were roses of light; while, in the distance, the customary roads, like slow movements stretching their vermilion to the pearly horizon, climb towards the sun.

Indeed, the diamonded gown of this fine summer clothes no other garden with so pure a brightness. And the unique joy sprung up in our two hearts discovers its own life in these clusters of flames.

XIX

May your bright eyes, your eyes of summer, be for me here on earth the images of goodness.

Let our enkindled souls clothe with gold each flame of our thoughts.

May my two hands against your heart be for you here on earth the emblems of gentleness.

Let us live like two frenzied prayers straining at all hours one towards the other.

May our kisses on our enraptured mouths be for us here on earth the symbols of our life.

XX

Tell me, my simple and tranquil sweetheart, tell me how much an absence, even of a day, saddens and stirs up love, and reawakens it in all its sleeping scalds?

I go to meet those who are returning from the wondrous distances to which at dawn you went; I sit beneath a tree at a bend of the path, and, on the road, watching their coming, I gaze and gaze earnestly at their eyes still bright with having seen you.

And I would kiss their fingers that have touched you, and cry out to them words they would not understand; and I listen a long while to the rhythm of their steps towards the shadow where the old evenings hold night prone.

XXI

During those hours wherein we are lost so far from all that is not ourselves, what lustral blood or what baptism bathes our hearts that strain towards all love?

Clasping our hands without praying, stretching out our arms without crying aloud, but with earnest and ingenuous mind worshipping something farther off and purer than ourselves, we know not what, how we blend with, how we live our lives in, the unknown.

How overwhelmed we are in the presence of those hours of supreme existence; how the soul desires heavens in which to seek for new gods.

Oh! the torturing and wondrous joy and the daring hope of being one day, across death itself, the prey of these silent terrors.

XXII

Oh! this happiness, sometimes so rare and frail that it frightens us!

In vain we hush our voices, and make of all your hair a tent to shelter us; often the anguish in our hearts flows over.

But our love, being like a kneeling angel, begs and supplicates that the future give to others than ourselves a like affection and life, so that their fate may not be envious of ours.

And, too, on evil days, when the great evenings extend to heaven the bounds of despair, we ask forgiveness of the night that kindles with the gentleness of our heart.

XXIII

Let us, in our love and ardour, let us live so boldly our finest thoughts that they interweave in harmony with the supreme ecstasy and perfect fervour.

Because in our kindred souls something more holy than we and purer and greater awakens, let us clasp hands to worship it through ourselves.

It matters not that we have only cries or tears to define it humbly, and that its charm is so rare and powerful that, in the enjoyment of it, our hearts are nigh to failing us.

Even so, let us remain, and for ever, the mad devotees of this almost implacable love, and the kneeling worshippers of the sudden God who reigns in us, so violent and so ardently gentle that he hurts and overwhelms us.

XXIV

So soon as our lips touch, we feel so much more luminous together that it would seem as though two Gods loved and united in us.

We feel our hearts to be so divinely fresh and so renewed by their virgin light that, in their brightness, the universe is made manifest to us.

In our eyes, joy is the only ferment of the world that ripens and becomes fruitful innumerably on our roads here below; as in clusters spring up among the silken lakes on which sails travel the myriad blossoms of the stars above.

Order dazzles us as fire embers, everything bathes us in its light and appears a torch to us: our simple words have a sense so lovely that we repeat them to hear them without end.

We are the sublime conquerors who vanquish eternity without pride and without a thought of trifling time: and our love seems to us always to have been.

XXV

To prevent the escape of any part of us from our embrace that is so intense as to be holy, and to let love shine clear through the body itself, we go down together to the garden of the flesh.

Your breasts are there like offerings and your two hands are stretched out to me; and nothing is of so much worth as the simple provender of words said and heard.

The shadow of the white boughs travels over your neck and face, and your hair unloosens its bloom in garlands on the swards.

The night is all of blue silver; the night is a lovely silent bed—gentle night whose breezes, one by one, will strip the great lilies erect in the moonlight.

XXVI

Although autumn this evening along the paths and the woods' edges lets the leaves fall slowly like gilded hands;

Although autumn this evening with its arms of wind harvests the petals and their pallor of the earnest rose-trees;

We shall let nothing of our two souls fall suddenly with these flowers.

But before the flames of the golden hearth of memory, we will both crouch and warm our hands and knees.

To guard against the sorrows hidden in the future, against time that makes an end of all ardour, against our terror and even against ourselves, we will both crouch near the hearth that our memory has lit up in us.

And if autumn involves the woods, the lawns and the ponds in great banks of shadow and soaring storms, at least its pain shall not disturb the inner quiet garden where the equal footsteps of our thoughts walk together in the light.

XXVII

The gift of the body when the soul is given is but the accomplishment of two affections drawn headlong one towards the other.

You are only happy in your body that is so lovely in its native freshness because in all fervour you may offer it to me wholly as a total alms.

And I give myself to you knowing nothing except that I am greater by knowing you, who are ever better and perhaps purer since your gentle body offered its festival to mine.

Love, oh! let it be for us the sole discernment and the sole reason of our heart, for us whose most frenzied happiness is to be frenzied in our trust.

XXVIII

Was there in us one fondness, one thought, one gladness, one promise that we had not sown before our footsteps?

Was there a prayer heard in secret whose hands stretched out gently over our bosom we had not clasped?

Was there one appeal, one purpose, one tranquil or violent desire whose pace we had not quickened?

And each loving the other thus, our hearts went out as apostles to the gentle, timid and chilled hearts of others;

And by the power of thought invited them to feel akin to ours, and, with frank ardours, to proclaim love, as a host of flowers loves the same branch that suspends and bathes it in the sun.

And our soul, as though made greater in this awakening, began to celebrate all that loves, magnifying love for love's sake, and to cherish divinely, with a wild desire, the whole world that is summed up in us.

XXIX

The lovely garden blossoming with flames that seemed to us the double or the mirror of the bright garden we carried in our hearts is crystallized in frost and gold this evening.

A great white silence has descended and sits yonder on the marble horizons, towards which march the trees in files, with their blue, immense and regular shadow beside them.

No puff of wind, no breath. Alone, the great veils of cold spread from plain to plain over the silver marshes or crossing roads.

The stars appear to live. The hoar-frost shines like steel through the translucent, frozen air. Bright powdered metals seem to snow down, in the infinite distances, from the pallor of a copper moon. Everything sparkles in the stillness.

And it is the divine hour when the mind is haunted by the thousand glances that are cast upon earth by kind and pure and unchangeable eternity towards the hazards of human wretchedness.

XXX

If it should ever happen that, without our knowledge, we became a pain or torment or despair one to the other;

If it should come about that weariness or hackneyed pleasure unbent in us the golden bow of lofty desire;

If the crystal of pure thought must fall in our hearts and break;

If, in spite of all, I should feel myself vanquished because I had not bowed my will sufficiently to the divine immensity of goodness;

Then, oh! then let us embrace like two sublime madmen who beneath the broken skies cling to the summits even so—and with one flight and soul ablaze grow greater in death.

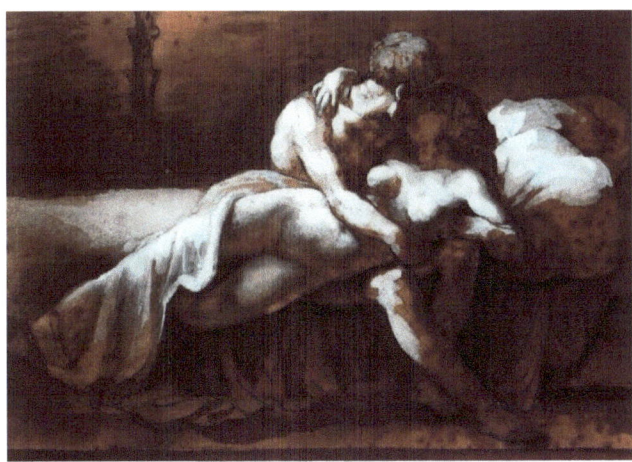

The Kiss--Theodore Gericault--Romanticism

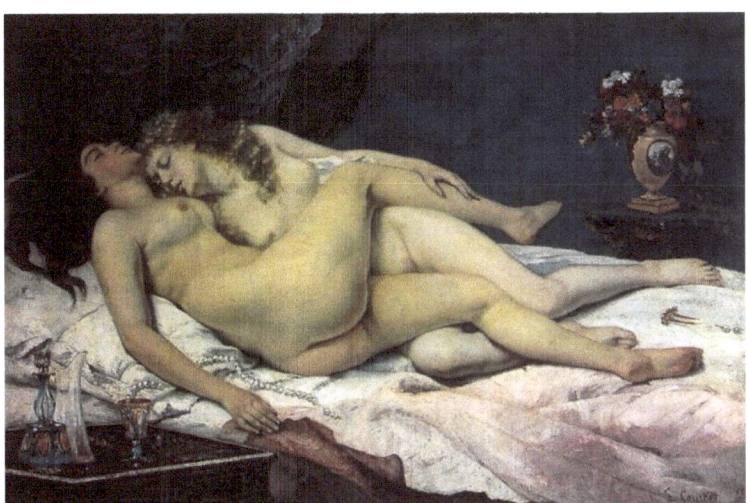

The Sleepers--Gustave Courbet-- Le Sommeil—1866--Realism

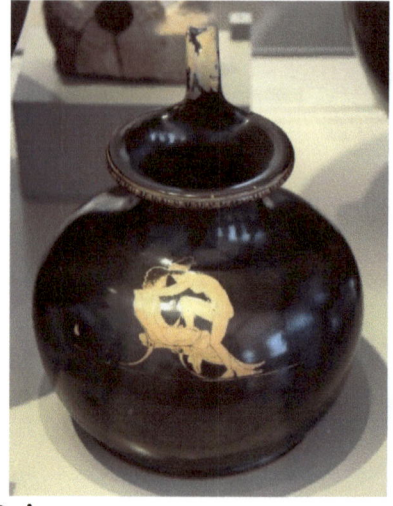

Oinochoe by the Shuvalov Painter

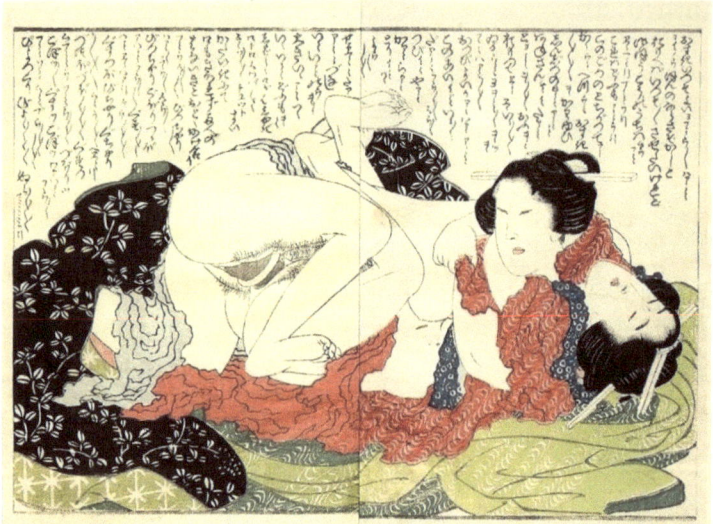

Two Women Having Sex With One Of Them Wearing A Harikata (Artificial Phallus)--
Katsushika Hokusai--Ukiyo-e

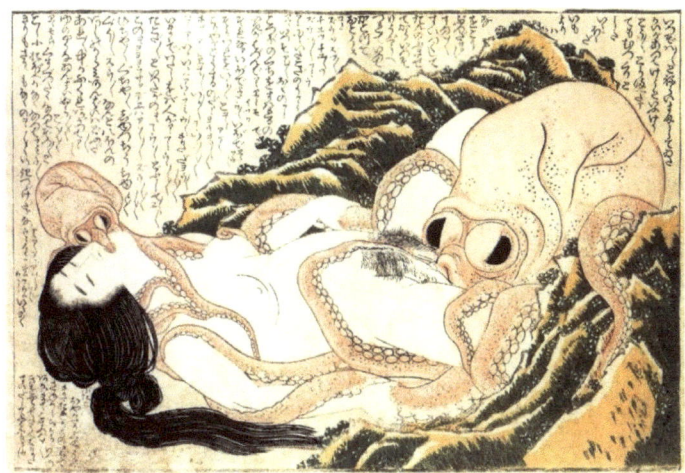

The Dream Of The Fisherman's Wife

-- 蛸と海女--Katsushika Hokusai—1814-- Ukiyo-e

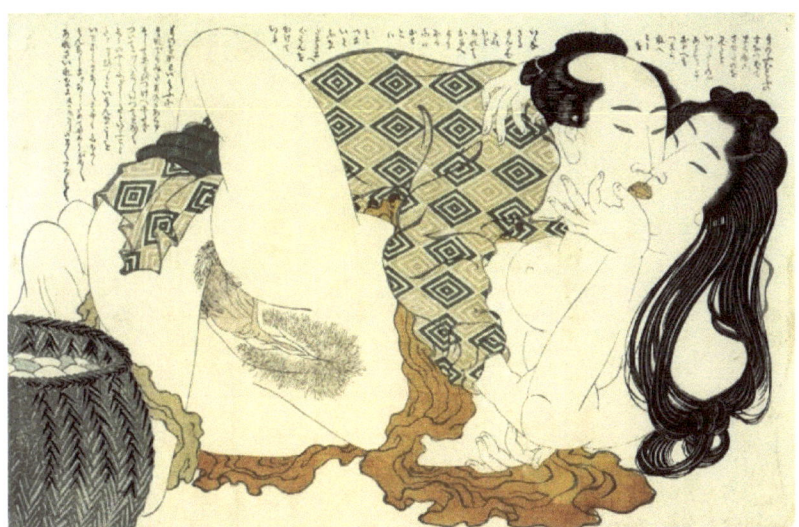

The Adonis Plant--Katsushika Hokusai—1815-- Ukiyo-e

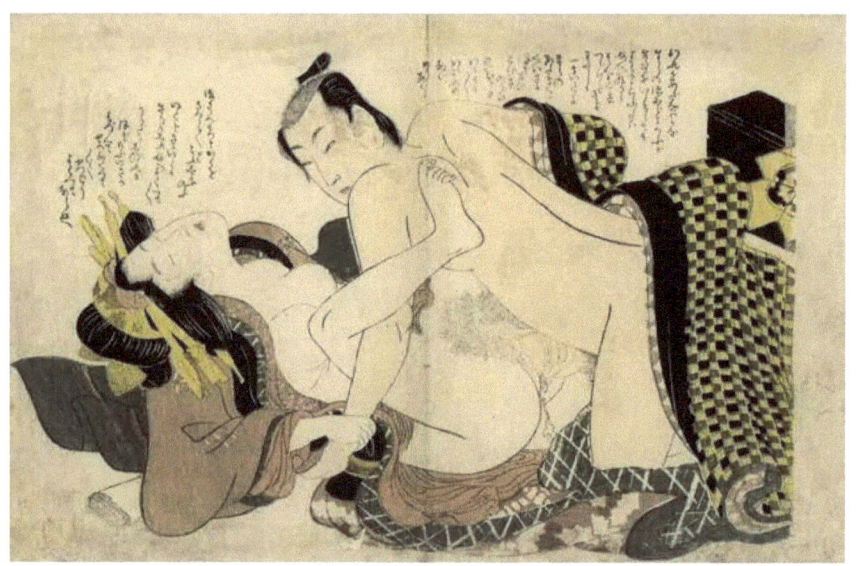

The Adonis Plant--Katsushika Hokusai—1815-- Ukiyo-e

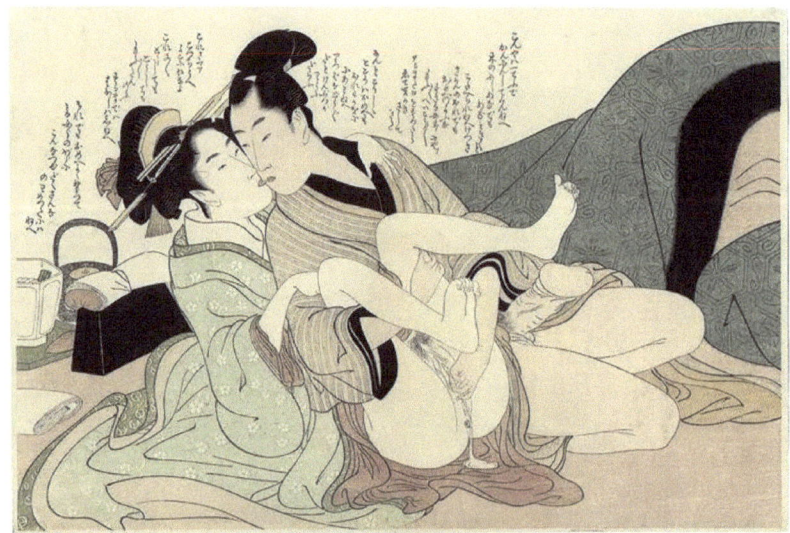

Young Courtesan With Her Lover--Kitagawa Utamaro—1799-- Ukiyo-e

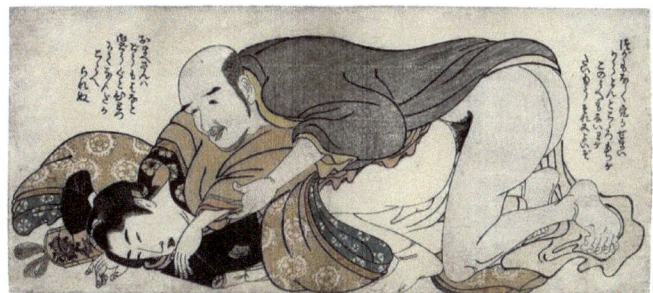

Male Couple--Kitagawa Utamaro—1802-- Ukiyo-e

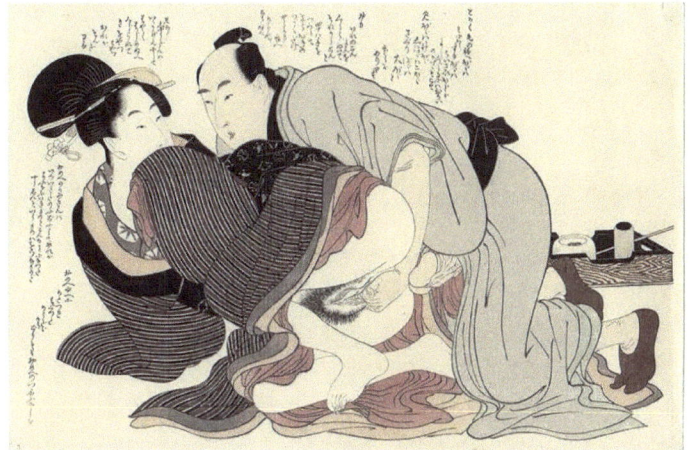

A Married Man And A Spinster--Kitagawa Utamaro—1799-- Ukiyo-e

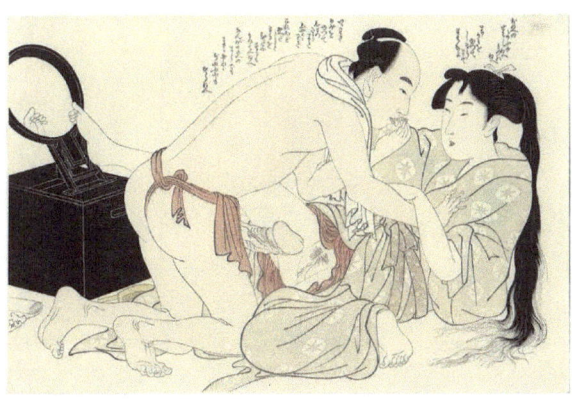

A Man Interrupts Woman Combing Her Long Hair--Kitagawa Utamaro—1799--

Ukiyo-e

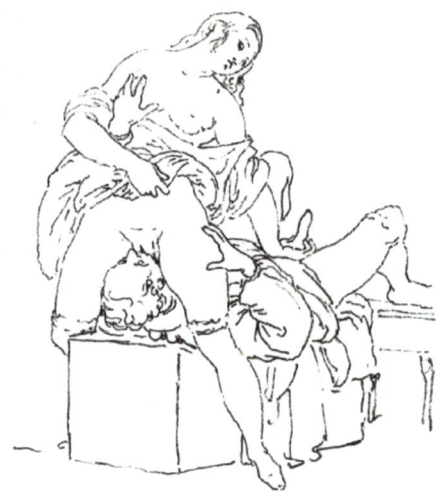

Cunnilingus, Or Oral Sex Performed On A Woman--Francesco Hayez--Romanticism

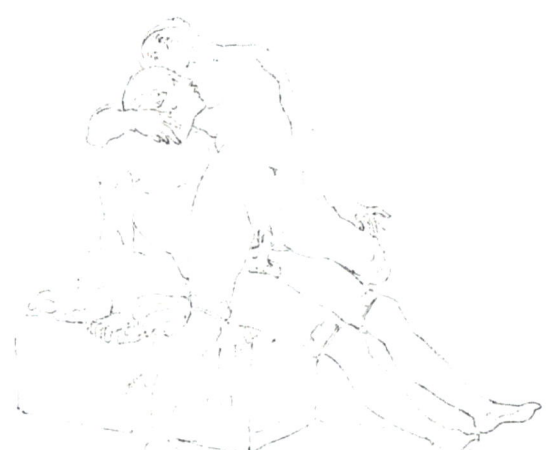

Overlapping Wife Back Position On The Swing--Francesco Hayez--Romanticism

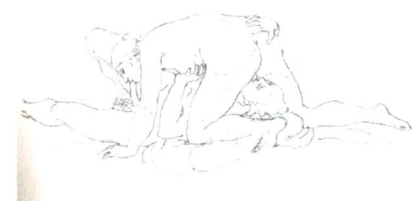

Fellatio, Or Oral Sex Performed On A Man--Francesco Hayez-- Romanticism

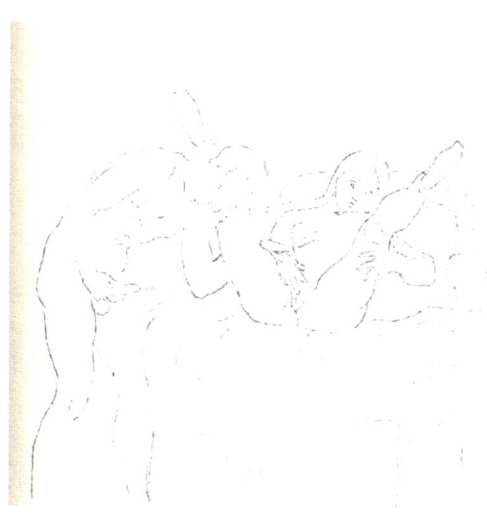

Sexual Intercourse--Francesco Hayez-- Romanticism

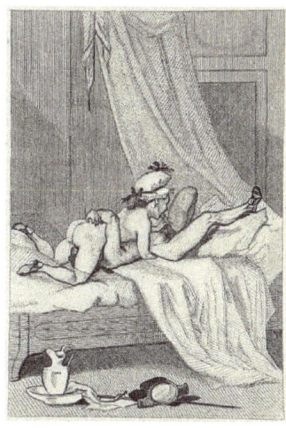

Sex Position '69'--Felicien Rops--Symbolism

The Devil And Eve In The Garden Of Eden--Felicien Rops-- Symbolism

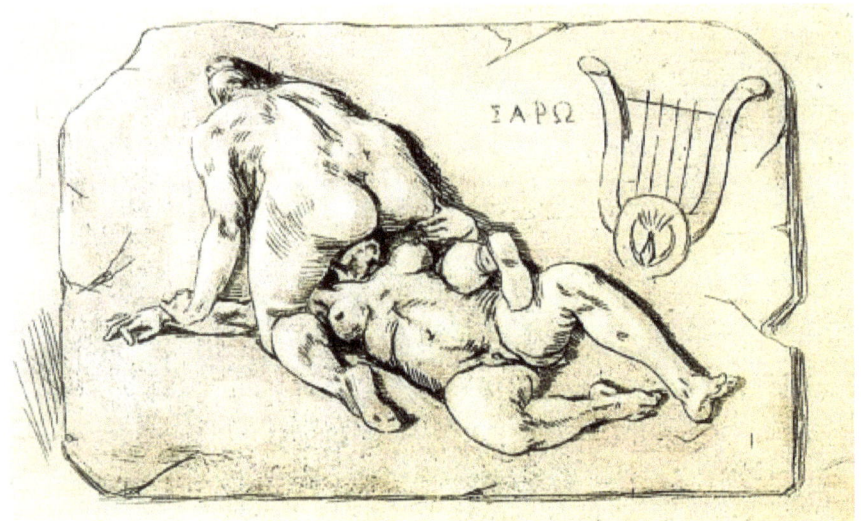

Lesbos, Known As Sappho--Felicien Rops—1890-- Symbolism

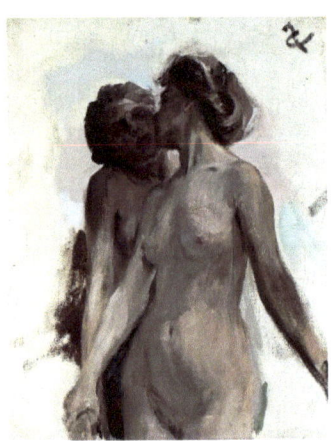

Symbolic dance--Jan Ciągliński

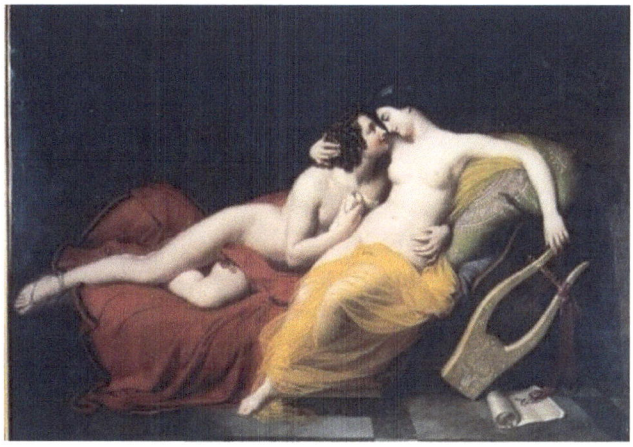

Sappho et Phaon--Pierre Claude François Delorme

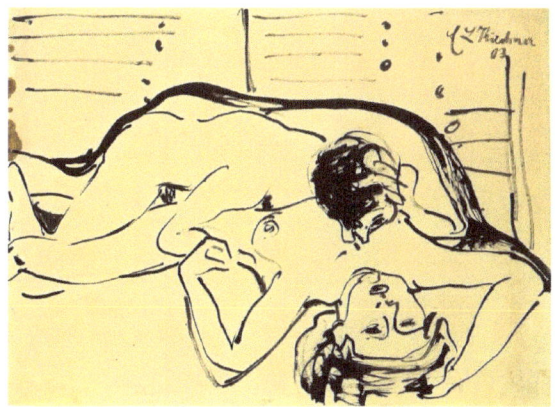

Ernst Ludwig Kirchner--Lovers--1909

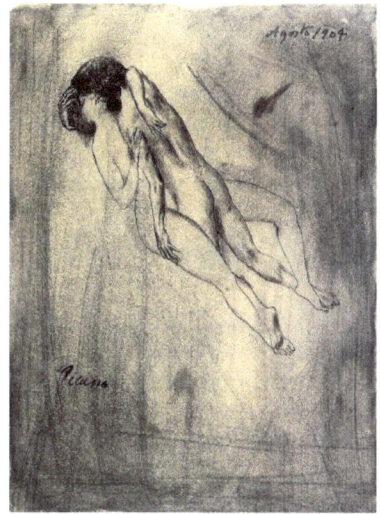

Lovers(Les amants)--Pablo PicassoPablo—1904-- Expressionism

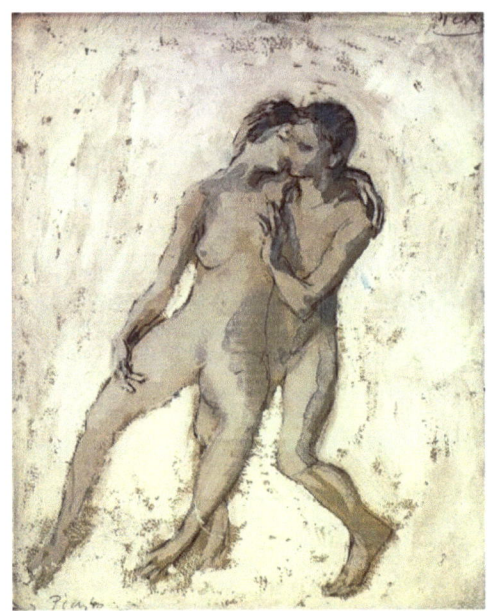

Nudes Interlaces(Nus entrelace)--Pablo Picasso—1905-- Post-Impressionism

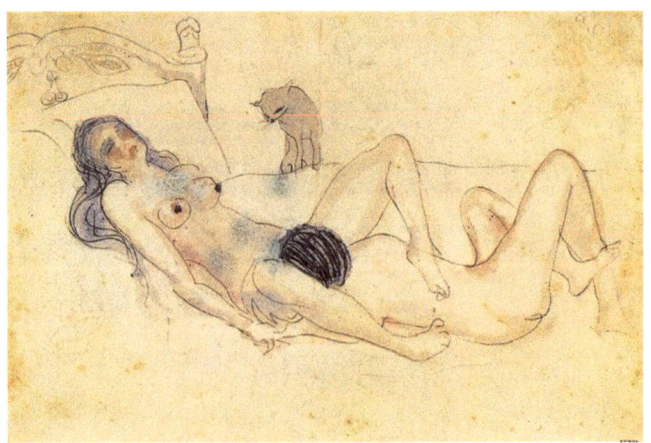

Two Nudes And A Cat (Deux nus et un chat) --Pablo Picasso—1903-- Post-Impressionism

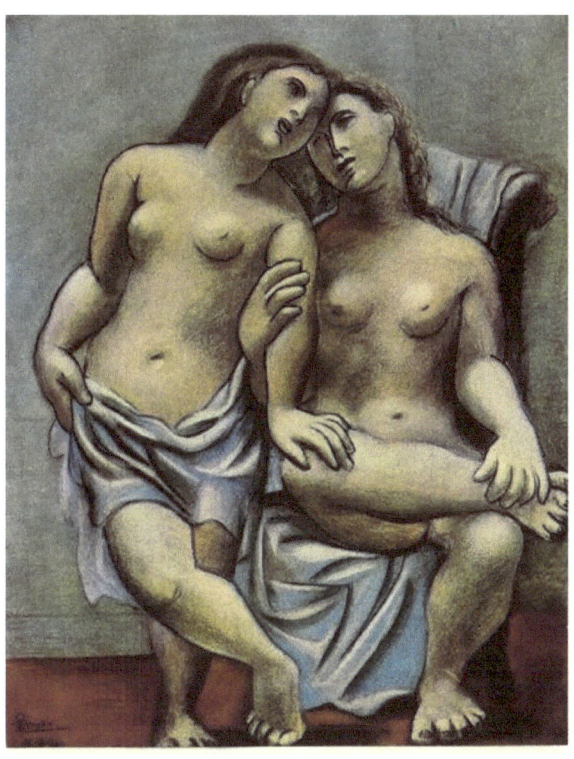

Two Nude Women (Deux femmes nu)--Pablo Picasso—1920-- Neoclassicism

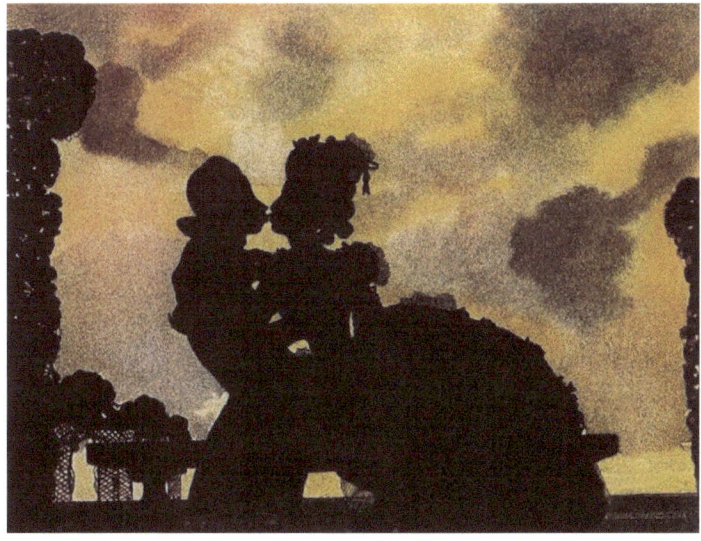

The Kiss (Silhouette)-- Поцелуй (Силуэт)--

Konstantin Somov—1906-- Symbolism